ENTROPY AND ART

Nous causâmes aussi de l'univers, de sa création
et de sa future destruction; de la grande idée
du siècle, c'est-à-dire du progrès et de la
perfectibilité, et, en général, de toutes
les formes de l'infatuation humaine.

Baudelaire, 1869

ENTROPY AND ART

AN ESSAY ON DISORDER AND ORDER

RUDOLF ARNHEIM

UNIVERSITY OF CALIFORNIA PRESS
BERKELEY · LOS ANGELES · LONDON

University of California Press
Berkeley and Los Angeles, California
University of California Press, Ltd.
London, England
Copyright © 1971, by
The Regents of the University of California
First Paperback Edition 1974
ISBN: 0–520–02617–9
Library of Congress Catalog Card Number: 71–128585
Printed in the United States of America
Designed by Dave Comstock

4 5 6 7 8 9 0

The passage from Hans Arp's *On My Way*,
Documents of Modern Art Series No. 6,
George Wittenborn, Inc., New York,
is quoted with permission of the publisher.

IN MEMORY OF
WOLFGANG KÖHLER

CONTENTS

In many instances, order is apprehended first of all by the senses. The observer perceives an organized structure in the shapes and colors or sounds facing him. But it is hard, perhaps impossible, to find examples in which the order of a given object or event is limited to what is directly apparent in perception. Rather, the perceivable order tends to be manifested and understood as a reflection of an underlying order, whether physical, social, or cognitive. Our kinesthetic sense tells us through our muscular reactions whether a device or engine works with a smooth ordering of its parts; in fact, it informs us similarly about the perfect or imperfect functioning of our own bodies. The spatial layout of a building reflects and serves the distribution and interconnections of various functions; the groupings of the cans and packages on the shelves of a store guide the customer to the ordered varieties of household goods, and the shapes and colors of a painting or the sounds of a piece of music symbolize the interaction of meaningful entities.

Since outer order so often represents inner or functional order, orderly form must not be evaluated by itself, that is, apart from its relation to the organization it signifies. The form may be quite orderly and yet misleading, because its structure does not correspond to the order it stands for. Blaise Pascal observes in his *Pensées* (Sect. 1, no. 27): "Those who make antitheses by forcing the words are like those who make false windows for symmetry's sake: their rule is not to speak right but to make right figures." A lack of correspondence between outer and inner order produces a clash of orders, which is to say that it introduces an element of disorder.

External orderliness hiding disorder may be experienced as offensive. Michel Butor, discussing the New York City of the 1950s, speaks of

> marvelous walls of glass with their delicate screens of horizontals and verticals, in which the sky reflects itself; but inside those buildings all the scraps of Europe are piled up in confusion. Those admirable large rectangles, in plan or

2

i

Order is a necessary condition for anything the human mind is to understand. Arrangements such as the layout of a city or building, a set of tools, a display of merchandise, the verbal exposition of facts or ideas, or a painting or piece of music are called orderly when an observer or listener can grasp their overall structure and the ramification of the structure in some detail. Order makes it possible to focus on what is alike and what is different, what belongs together and what is segregated. When nothing superfluous is included and nothing indispensable left out, one can understand the interrelation of the whole and its parts, as well as the hierarchic scale of importance and power by which some structural features are dominant, others subordinate.

elevation, make the teeming chaos to which they are basically unrelated particularly intolerable. The magnificent grid is artificially imposed upon a continent that has not produced it; it is a law one endures (18, p. 354).

Furthermore, order is a necessary condition for making a structure function. A physical mechanism, be it a team of laborers, the body of an animal, or a machine, can work only if it is in physical order. The mechanism must be organized in such a way that the various forces constituting it are properly attuned to one another. Functions must be assigned in keeping with capacity; duplications and conflicts must be avoided. Any progress requires a change of order. A revolution must aim at the destruction of the given order and will succeed only by asserting an order of its own.

Order is a prerequisite of survival; therefore the impulse to produce orderly arrangements is inbred by evolution. The social organizations of animals, the spatial formations of travelling birds or fishes, the webs of spiders and bee hives are examples. A pervasive striving for order seems to be inherent also in the human mind—an inclination that applies mostly for good practical reasons.

REFLECTIONS OF PHYSICAL ORDER

However, practicality is not the only consideration. There are forms of behavior suggesting a different impulse. Why would experiments in perception show that the mind organizes visual patterns spontaneously in such a way that the simplest available structure results?* To be sure, one might surmise that all perception involves a desire to understand and that the simplest, most orderly structure facilitates understanding. If a line figure (Figure 1a) can be seen as a combination of square and circle, it is more readily apprehended than the combination of three units indicated in Figure 1b. Even so, another explanation imposes itself when one remembers that such elementary

* For the literature on perceptual organization see Arnheim (5, chap. 2).

3

perceptual behavior is but a reflection of analogous physiological processes taking place in the brain. If there were independent evidence to make it likely that a similar tendency toward orderly structure exists in these brain processes also, one might want to think of perceptual order as the conscious manifestation of a more universal physiological and indeed physical phenomenon.

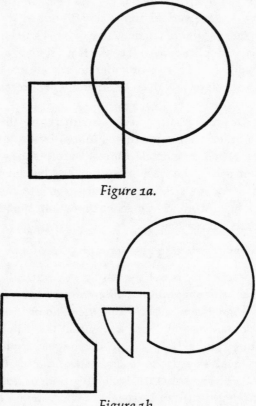

Figure 1a.

Figure 1b.

The corresponding activities in the brain would have to be field processes because only when the forces constituting a process are sufficiently free to interact can a pattern organize itself spontaneously according to the structure prevailing in

4

the whole. No known fact prevents us from assuming that such field processes do indeed take place in the sensory areas of the brain.* They are quite common in physics. It was Wolfgang Köhler who, impressed by the gestalt law of simple structure in psychology, surveyed corresponding phenomena in the physical sciences in his book on the "physical gestalten," a *naturphilosophische* investigation published in 1920 (40). In a later paper he noted:

> In physics we have a simple rule about the nature of equilibria, a rule which was independently established by three physicists: E. Mach, P. Curie, and W. Voigt. They observed that in a state of equilibrium, processes—or materials—tend to assume the most even and regular distributions of which they are capable under the given conditions (39, p. 500).

Two examples may convey an idea of this sort of physical behavior. The physicist Sir Joseph J. Thomson once illustrated the equilibrium of corpuscles in a plane by the behavior of

* This continues to be true even though an important group of recent experiments has shown that the smallest units subjected to perceptual organization are not necessarily the single point-sized receptors in the retina and their equally elementary counterparts at the various processing levels, especially in the cerebrum. Instead, animal experiments indicate that groups of special receptors co-operate to signal the presence of certain basic shapes, movements, or spatial orientations in the visual field. The best known examples are the "bug detectors" in the frog's retina, which respond only to moving, dark, convex objects in the field. [For a survey of the findings and their possible application to human vision see Weisstein (68).] These are biological short cuts to perceptual organization. The perception of certain standard items of the environment is delegated to local and apparently quite independent organizational processes. The studies show that perceptual organization begins at a much more peripheral level than we were used to assuming; but by no means do they suggest that what an animal or person perceives comes about as the sum of standardized subunits. Typical perceptual organization, of which Figure 1 (p. 4) is an elementary example, continues to require field processes, in which the parts are determined by the structure of the whole.

5

magnetized needles pushed through cork discs that float on water. The needles, having their poles all pointing the same way, repel each other like the atomic corpuscles. A large magnet is placed above the surface of the water, its lower pole being of the opposite sign to that of the upper poles of the floating magnets. Under these conditions, the needles, which repel each other but are attracted by the larger magnet, will arrange themselves on the surface of the water around the center of attraction in the simplest possible form: three needles in a triangle, four at the corners of a square, five at the corners of a pentagon. Thus orderly shape results from the balancing of the antagonistic forces (65, p. 110).* The same kind of effect can be observed in another demonstration (Plate 1), intended to simulate the behavior of propellant gases and liquids under conditions of zero-gravity. A lucite model of the Centaur fuel tank is filled with clear oil and colored water. Both are of equal density and do not mix, "and the natural surface of the water forms an interface of constant equal tension between them, which is almost like a membrane."† Variously agitated or rotated, the segregating surface assumes all sorts of accidental shapes. But when outside interference ceases, the forces inherent in the two liquids organize themselves to constitute an overall state of equilibrium or minimum tension, which results in perfectly regular spherical shape—the simplest shape available under the circumstances.

Such demonstrations show that orderly form will come about as the visible result of physical forces establishing, under field conditions, the most balanced configurations attainable. This

* The same illustration is used by Sir William Bragg (16, p. 38). Thomson mentions that the method was "introduced for a different purpose by an American physicist, Professor Mayer." I am indebted for this reference as well as for other valuable suggestions to Professors Gerald Holton and Thomas von Foerster of the Department of Physics at Harvard University.
† Advertisement in the *Scientific American*, from which Plate 1 has been adapted by permission of General Dynamics/Astronautics, San Diego, California.

is true for inorganic as well as organic systems, for the symmetries of crystals as well as those of flowers or animal bodies.*

What shall we make of this similarity of organic and inorganic striving? Is it by mere coincidence that order, developing everywhere in organic evolution as a condition of survival and realized by man in his mental and physical activities, is also striven for by inanimate nature, which knows no purpose? The preceding examples have shown that the forces constituting a physical field have no alternative. They cannot cease to rearrange themselves until they block each other's movement by attaining a state of balance. The state of balance is the only one in which the system remains at rest, and balance makes for order because it represents the simplest possible configuration of the system's components. A proper version of order, however, is also a prerequisite of good functioning and is aspired to for this reason also by organic nature and by man.

DISORDER AND DEGRADATION

The vision of such harmonious striving for order throughout nature is disturbingly contradicted by one of the most influential statements on the behavior of physical forces, namely, the Second Law of Thermodynamics. The most general account physicists are willing to give of changes in time is often formulated to mean that the material world moves from orderly states to an ever-increasing disorder and that the final situation of the universe will be one of maximal disorder. Thus Max Planck, in his lectures on theoretical physics delivered at Columbia University in 1909, said:

* The term "order" is used here not, or not only, in the sense of what works best in our particular environment but as an objective description of the simplest, most symmetrical, most regular form. The shape of a chicken egg is less simple, and in this sense, of a more complex order than that of a sphere; but it is better adapted to its mechanical function than a spherical egg would be. Most animal bodies are adapted to the one-sided stress of the earth's gravitational field by being symmetrical only about a plane, not about the center.

Therefore, it is not the atomic distribution, but rather the hypothesis of elementary disorder, which forms the real kernel of the principle of increase of entropy and, therefore, the preliminary condition for the existence of entropy. Without elementary disorder there is neither entropy nor irreversible process (55, p. 50).

And in a recent book, Angrist and Hepler formulate the Second Law as follows: "Microscopic disorder (entropy) of a system and its surroundings (all of the relevant universe) does not spontaneously decrease" (3, p. 151). In this sense, therefore, entropy is defined as the quantitative measure of the degree of disorder in a system—a definition that, as we shall see, is in need of considerable interpretation.

Modern science, then, maintains on the one hand that nature, both organic and inorganic, strives towards a state of order and that man's actions are governed by the same tendency. It maintains on the other hand that physical systems move towards a state of maximum disorder. This contradiction in theory calls for clarification. Is one of the two assertions wrong? Are the two parties talking about different things or do they attach different meanings to the same words?

The First Law of Thermodynamics referred to the conservation of energy. It stated that energy may be changed from one form to another but is neither created nor destroyed. This could sound unpleasant if one took it to mean (as one of the leading physicists of the time, John Tyndall, actually did) that "the law of conservation excludes both creation and annihilation" (66, lect. 17, p. 536). Commonly, however, a more positive interpretation prevailed. The law seemed to assure conservative minds that in spite of all violent upsets everything could be expected to stay the same in the end. The image of "a world of law, order, and timeless permanence" served theologians as a confirmation of "God's presence and action" (34, p. 1062).

The popular connotations of the Second Law of Thermo-

dynamics were quite different. When it began to enter the
public consciousness a century or so ago, it suggested an apoc-
alyptic vision of the course of events on earth. The Second
Law stated that the entropy of the world strives towards a
maximum, which amounted to saying that the energy in the
universe, although constant in amount, was subject to more
and more dissipation and degradation. These terms had a dis-
tinctly negative ring. They were congenial to a pessimistic
mood of the times. Stephen G. Brush, in a paper on thermo-
dynamics and history, points out that in 1857 there were
published in France Bénédict Auguste Morel's *Traité des dé-
générescences physiques, intellectuelles et morales de l'espèce
humaine* as well as Charles Baudelaire's *Fleurs du mal* (17, p.
505). The sober formulations of Clausius, Kelvin, and Boltz-
mann were suited to become a cosmic memento mori, pointing
to the underlying cause of the gradual decay of all things phys-
ical and mental. According to Henry Adams' witty treatise, *The
Degradation of the Democratic Dogma*, "to the vulgar and
ignorant historian it meant only that the ash heap was con-
stantly increasing in size" (1, p. 142). The sun was getting
smaller, the earth colder, and no day passed without the French
or German newspapers

> producing some uneasy discussion of supposed social de-
> crepitude; falling off of the birthrate; —decline of rural
> population; —lowering of army standards;—multiplication
> of suicides;—increase of insanity or idiocy,—of cancer, —of
> tuberculosis; —signs of nervous exhaustion,—of enfeebled
> vitality, —"habits" of alcoholism and drugs,—failure of eye-
> sight in the young—and so on, without end. . . (1, p. 186).

This was in 1910. In 1892, Max Nordau had published his
famous *Degeneration*—a book most symptomatic of the *fin de
siècle* mood, although it cannot be said to imply that mankind
as a whole was on its way out (51). In his diatribe of nearly a
thousand pages, the Hungarian physician and writer, basing

his contentions on the work of Morel and Lombroso, denounced the wealthy city dwellers and their artists, composers, and writers as hysterics and degenerates. For instance, he thought that the pictorial style of the Impressionists was due to the nystagmus found in the eyes of "degenerates" and the partial anesthesia of the retinae in hysterics. He attributed the high incidence of degeneration to nervous exhaustion produced by modern technology as well as to alcohol, tobacco, narcotics, syphilis. But he predicted that in the twentieth century mankind would prove healthy enough to either tolerate modern life without harm or reject it as intolerable (51, p. 508ff).

Today we no longer regard the universe as the cause of our own undeserved troubles but perhaps, on the contrary, as the last refuge from the mismanagement of our earthly affairs. Even so, the law of entropy continues to make for a bothersome discrepancy in the humanities and helps to maintain the artificial separation from the natural sciences. Lancelot L. Whyte, acutely aware of the problem, formulated it by asking: "What is the relation of the two cosmic tendencies: towards mechanical disorder (entropy principle) and towards geometrical order (in crystals, molecules, organisms, etc.)?" (70, p. 27).

The visual arts have recently presented us with two stylistic trends which, at first look, may seem quite different from each other but which the present investigation may reveal to have common roots. On the one hand, there is a display of extreme simplicity, initiated as early as 1913 by the Russian painter Kasimir Malevich's Suprematist black square on a white ground (21, p. 342). This tendency has a long history in the more elementary varieties of ornamentation as well as the frugal design of many functional objects through the ages. In our own day, we have pictures limited to a few parallel stripes, canvases evenly stained with a single color, bare boxes of wood or metal, and so forth. The other tendency, relying on accidental or deliberately produced disorder, can be traced back to a predilection for compositions of randomly gathered subject matter in Dutch still lifes, untidy scenes of social criticism in

the generation of Hogarth, groups of unrelated individuals in French genre scenes of the nineteenth century, and so on (4). In modern painting we note the more or less controlled splashes and sprays of paint, in sculpture a reliance on chance textures, tears or twists of various materials, and found objects. Related symptoms in other branches of art are the use of random sequences of words or pages in literature, or a musical performance presenting nothing but silence so that the audience may listen to the noises of the street outside. In the writings of the composer John Cage, one finds observations such as the following:

I asked him what a musical score is now.
He said that's a good question.
I said: Is it a fixed relationship of parts?
He said: Of course not; that would be insulting. (19, p. 27)

Magazine and newspaper critics often discuss these phenomena with the bland or tongue-in-cheek objectivity of the reporter. Or they attribute to elementary signs the power of consummate symbols, for instance, by accepting a simple arrow as the expression of cosmic soaring or descent, or the crushed remains of an automobile as an image of social turmoil. When they condemn such work, they tend to accuse the artists of impertinence and lack of talent or imagination without at the same time evaluating the work as symptomatic and analyzing its cause and purpose. Aesthetic and scientific principles do not seem to be readily at hand.

Occasional explicit references to entropy can be found in critical writing. Richard Kostelanetz, in an article on "Inferential Arts," quotes Robert Smithson's *Entropy and the New Monuments* as saying of recent towering sculptures of basic shapes that they are "not built for the ages but rather against the ages" and "have provided a visible analogue for the Second Law of Thermodynamics" (42, p. 22). Surely the popular use of the notion of entropy has changed. If during the last century it served to diagnose, explain, and deplore the degradation of

culture, it now provides a positive rationale for "minimal" art and the pleasures of chaos.*

WHAT THE PHYSICIST HAS IN MIND

Turning from the bravura of the market place to the theoretical issues, one may want to ask first of all: What is it that induces physicists to describe the end state of certain material systems as one of maximal disorder, that is, to use descriptive terms of distinctly negative connotation? For the answer one must look at their view of (a) the shape situations and (b) the dynamic configurations prevailing in early and late states of physical systems. Here one discovers, first of all, that the processes measured by the principle of entropy are perceived as the gradual or sudden destruction of inviolate objects—a degradation involving the breaking-up of shape, the dissolution of functional contexts, the abolition of meaningful location. P. T. Landsberg in a lecture, *Entropy and the Unity of Knowledge*, chooses the following characteristic example:

> Tidy away all your children's toys in a toy cupboard, and the probability of finding part of a toy in a cubic centimeter is highly peaked in the region of the cupboard. Release a randomizing influence in the form of an untidy child, and the distribution for the system will soon spread (45, p. 16).

The child's playroom can indeed serve as an example of disorder—especially if we do not grant the child a hearing to defend the hidden order of his own toy arrangements as he sees them. But the messed-up room is not a good example of a final thermodynamic state. The child may have succeeded in breaking all the functional and formal ties among his implements by destroying the initial order and replacing it with one of many possible, equally arbitrary arrangements. Thereby he

* Cf. Monroe C. Beardsley's ironical comment: ". . . because the Second Law of Thermodynamics promises an inexorable downhill march to a statistical heat-death, what else can a conscientious artist do but play along with nature by maximizing the entropy of his work?" (11, p. 196).

may have increased the probability that the present kind of state may come about by chance, which amounts to a respectable increase of entropy. He may even have dispersed the pieces of a jigsaw puzzle or broken a fire engine, thereby extending disintegration somewhat beyond the relations among complete objects to include the relations among parts.

Nevertheless, the child is a very inefficient randomizer. Failing to grind his belongings to a powder of independent molecules, he has preserved islands of untouched order everywhere. In fact, it is only because of this failure that the state of his room can be called disorderly. Disorder "is not the absence of all order but rather the clash of uncoordinated orders" (7, p. 125).*

The random whirling of elementary particles, however, does not meet this definition of disorder. Although it may have come about by dissolution, it is actually a kind of order. This will become clearer if I refer to another common model for the increase of entropy, namely shuffling (23, chap. 4). The usual interpretation of this operation is that by shuffling, say, a deck of cards one converts an initial order into a reasonably perfect disorder. This, however, can be maintained only if *any* par-

* W. Köhler: "The word *disorder* applies suitably to physical states in which a multiplicity of elements pursue mostly independent paths but, for short times, come into physical connection." (40, p. 180). Cf. also James K. Feibleman: "Disorder depends on the random dispersion of limited orders" (43, p. 11). In medical language, diseases are often called "disorders," meaning the lack of coordination among partial systems of the body or the mind. The British psychiatrist R.D. Laing comments on the case of one of his patients: "The overall unity of her being had broken up into several 'partial assemblies' or 'partial systems' (quasi-autonomous 'complexes,' 'inner objects') each of which had its own little stereotyped 'personality' (molar splitting). In addition, any actual sequence of behavior was fragmented in a much more minute manner (molecular splitting)" (44, p. 196). A visual parallel can be found in works of art that appear to consist of unrelatable units. The components strain to adapt to one another, fight each other, come apart. The disorderly pattern is perceived as a combination of independent units locked in unreadable conflict.

ticular initial sequence of cards in the deck is considered an order and if the purpose of the shuffling operation is ignored. Actually, of course, the deck is shuffled because all players are to have the chance of receiving a comparable assortment of cards. To this end, shuffling, by aiming at a random sequence, is meant to create a homogeneous distribution of the various kinds of cards throughout the deck. This homogeneity is the order demanded by the purpose of the operation. To be sure, it is a low level of order and, in fact, a limiting case of order because the only structural condition it fulfills is that a sufficiently equal distribution shall prevail throughout the sequence. A very large number of particular sequences can meet this condition; but it is an order nevertheless, similar, for example, to the sort of symmetry of a somewhat higher order that would exist in the initial set-up of a game in which every player would be dealt one card of each kind systematically.

Before shuffling, the initial sequence of the cards in the deck, if considered by and for itself, may have been quite orderly. Perhaps all the aces or all the deuces were lying together. But this order would be like the false windows in Pascal's example. It would be in discord with the very different order required for the game, and the false relation between form and function would constitute an element of disorder.

The orderliness inherent in the homogeneity of a sufficiently large random distribution is easily overlooked because the probability statistics of the entropy principle is no more descriptive of structure than a thermometer is of the nature of heat. Cyril S. Smith has observed: "Like molecular structure earlier, quantum mechanics began almost as a notational device, and even today physicists tend to ignore the rather obvious spatial structure underlying their energy-level notation" (62, p. 642). Pure thermodynamics, in the words of Planck, "knows nothing of an atomic structure and regards all substances as absolutely continuous" (55, p. 41; 38). In fact, the term *disorder*, when used by physicists in this connection, is intended to mean no more than that "the single elements, with which the statistical approach operates, behave in complete

independence from one another" (57, p. 42). It follows that the entropy principle defines order simply as an improbable arrangement of elements, regardless of whether the macro-shape of this arrangement is beautifully structured or most arbitrarily deformed; and it calls disorder the dissolution of such an improbable arrangement.

INFORMATION AND ORDER

The absurd consequences of neglecting structure but using the concept of order just the same are evident if one examines the present terminology of information theory. Here order is described as the carrier of information, because information is defined as the opposite of entropy, and entropy is a measure of disorder. To transmit information means to induce order. This sounds reasonable enough. Next, since entropy grows with the probability of a state of affairs, information does the opposite: it increases with its improbability. The less likely an event is to happen, the more information does its occurrence represent. This again seems reasonable. Now what sort of sequence of events will be least predictable and therefore carry a maximum of information? Obviously a totally disordered one, since when we are confronted with chaos we can never predict what will happen next. The conclusion is that total disorder provides a maximum of information; and since information is measured by order, a maximum of order is conveyed by a maximum of disorder. Obviously, this is a Babylonian muddle. Somebody or something has confounded our language.*

The cause of the trouble is that when we commonly talk about order we mean a property of structure. In a purely statistical sense, on the other hand, the term order can be used to

* In his editorial preface to the new edition of *Aspects of Form* (69, p. XVI), L.L. Whyte criticizes the neglect of "processes leading towards spatial order" and adds: "In my view Schrödinger insulted this pre-eminent class of processes by giving them a negative and, in certain technical respects, misleading name: *negative entropy* (now structural neg-entropy)."

describe a sequence or arrangement of items unlikely to come about by mere chance. Now in a world of totally unrelated items, which has the throwing of dice as its paradigm, all particular sequences or arrangements of items are equally unlikely to occur, whether a series of straight sixes or a totally irregular but particular sequence of the six digits. In the language of information theory, which ignores structure, each of these sequences carries a maximum amount of information, i.e., of order, unless the procedure happens to be applied to a world that exhibits regularities. Structure means to the information theorist nothing better than that certain sequences of items can be expected to occur.

Suppose you watch a straight line growing—a vapor trail in the sky or a black mark in an animated film or on the pad of an artist. In a world of pure chance, the probability of the line continuing in the same direction is minimal. It is reciprocal to the infinite number of directions the line may take. In a structured world, there is some probability that the straight line will continue to be straight. A person concerned with structure can attempt to derive this probability from his understanding of the structure. How likely is the airplane suddenly to change its course? Given the nature of the film or the artist's drawing, how likely is the straight line to continue? The information theorist, who persists in ignoring structure, can handle this situation only by deriving from earlier events a measure of how long the straightness is likely to continue. He asks: What was the length of the straight lines that occurred before in the same situation or in comparable ones? Being a gambler, he takes a blind chance on the future, on the basis of what happened in the past. If he bets on the regularity of straightness, it is only because straightness has been observed before or has been decreed by the rules of the game. A particular form of crookedness would do just as well as the straight line, if it happened to meet the statistical condition, in a world in which crookedness were the rule. Naturally, most of the time such predictions will be laborious and untrustworthy. Few things in this world can be safely predicted from the frequency of their

previous occurrence alone; and the voluntary abstinence by which pure statistics of this kind rejects any other criterion, that is to say, any understanding of structure, will make calculations very difficult.

Any predictable regularity is termed redundant by the information theorist because he is committed to economy: every statement must be limited to what is needed. He shares this commitment with scientists and artists; its meaning, however, depends on whether one chops up patterns into elementary bits or whether one treats them as structures.* A straight line reduced to a sequence of dots for the purpose of piecemeal analysis or transmission can be highly redundant; in the drawing of a geometrician, engineer, or artist it is not. The processions of almost identical human figures on the walls of San Apollinare Nuovo in Ravenna are not redundant. They are intended to impress the eyes of the beholders with the spectacle of a multitude of worshipers united in the same religious function. In our own day, Andy Warhol has presented one photograph in rows of identical reproductions in order to explore connotations of mechanical multiplication as a phenomenon of modern life. Structural redundancy does, of course, exist; but it depends entirely on how much repetition is required by the visual nature of the total pattern. The effect and meaning of the single unit varies with the number of its repetitions.

I remember seeing a child's drawing that represented a skyscraper building. The child had begun to put in the rows of windows but lost patience after a while and avoided further labor by the expedient shown in Figure 2. From the point of view of information theory, the child is to be applauded. He has recognized the redundancy of the window pattern and has practiced economy by a shortcut in communication. If his pro-

* A beautiful observation of the composer Arnold Schönberg is reported by John Cage, his disciple. When Schönberg, whose generation still believed in structure, was told that someone threatened to cut one of his works, he maintained that such cuts would not shorten the composition. It would still be a long piece, which would be too short in various places (19, p. 48).

cedure strikes us as amusing, it is because we realize that to display structure to the eyes is the very purpose of a picture. The child's procedure would be quite proper if the drawing were to be dictated over the telephone. One would say: "Make sixty rows of twelve windows each!"

In dealing with structure, as is constantly done in the arts, regularity of form is not redundancy. It does not diminish information and thereby diminish order. On the contrary, for the purposes of structure, regularity is a mainstay of order, and this order is the basic requirement for any adequate information about structured things. The word "information," taken literally, means to give form; and form needs structure. This is why the tempting prospect of applying information theory to the arts and thereby reducing aesthetic form to quantitative measurement has remained largely unrewarding. The more

Figure 2.

adequate the attempts to account for a sequence of items, e.g., in a piece of music by calculating the probability of its occurrence, the more necessary is it to consider complex structural factors; and this complexity of order tends to make the calculation impracticable (48; 49; 11).

At this point, a significant difference between information

theory and the entropy principle must be cleared up. The information theorist's object of inquiry is an individual sequence or some other arrangement of items reduced to such a sequence. He investigates the probability of its occurrence by establishing the number of possible sequences, one of which is the present one.

He asks how likely is a particular melody written by Mozart to continue in a certain way, given the tone sequences Mozart is known to have written on previous occasions. The less predictable the sequence, the more information the sequence will be said to yield, and if information is identified with order, the paradox I mentioned will occur and the least structured sequence will be called the most orderly.

Entropy theory, on the other hand, is not concerned with the probability of succession in a series of items but with the overall distribution of *kinds* of items in a given arrangement. The more remote the arrangement is from a random distribution, the lower will be its entropy and the higher its level of order. This implies the following difference between the two approaches: a highly randomized sequence will be said to carry much information because information is concerned with the probability of this particular sequence; a similarly randomized distribution will be called highly probable and therefore of low order by the entropy theorist because innumerable distributions of this *kind* can occur.* A sequence of fifty white balls followed by fifty black ones will be said to contain much

* The fact that in an unstructured combination of elements the particular sequences or arrangements employed do not matter but lead structurally always to one and the same condition is brought home forcefully by certain avant garde attempts in film editing or the multiplication or mixing of media to combine disparate elements more or less at random. They are all different but they all say the same thing: chaos!— which is very close to saying nothing. These new techniques, when handled with a competent sense of form, can develop new valid and perhaps beautiful structures. They are likely to be quite complex; but mere randomness of combination does not suffice to create readable complexity.

redundancy, little information, low order, if it occurs in an orderly world; the opposite will be true for a random sequence of white and black balls. The entropy theorist, on the other hand, will call the first distribution quite orderly because most unlikely to occur by chance. He will say of the random one that innumerable distributions of its kind can occur and that therefore it has low order and high entropy.

PROBABILITY AND STRUCTURE

The difference, then, is due to the fact that the entropy theorist is not concerned with sets of individual items. Such sets would be treated by him as microstates, which constitute nothing but "complexions" of overall situations. The particular nature of any one such state does not matter. Its structural uniqueness, orderliness or disorderliness does not count, and its entropy cannot be measured. What does matter is the totality of these innumerable complexions, adding up to a global macrostate.*

* Is it really sensible to call information and entropy inversely related measures, as Norbert Wiener does when he says that "the amount of information is a quantity which differs from entropy merely by its algebraic sign . . ." (71, p. 129)? The two measures could be reciprocal only if they referred to the same property of sets of items; but this they do not do, as I just pointed out. Entropy theory never leaves the world of pure chance, whereas information theory gets nowhere unless it does, because only then can it arrive at sequences varying in probability of occurrence. Its business is to predict likelihood of occurrence in a world in which sequences are not all equally likely to turn up. Ignoring these differences leads to much confusion. Wiener states, for example, that "a haphazard sequence of symbols can convey no information" (71, p. 6). This is by no means true, as any victim of lotteries or games of chance can testify. Information, as defined by the theory, is not "the measure of the regularity of a pattern," but rather the contrary. Nor can it be said that "regularity is to a certain extent an abnormal thing." It can be normal or abnormal, that is, likely or unlikely to turn up, depending on whether one is trying to predict the next hundred objects produced by an automobile factory or the next hundred items in a white elephant auction. Helmar Frank (28, p. 40), as cited by Manfred Kiemle (37, p. 30), has drawn attention to contradictions in Wiener's statements.

Think of a glassful of water, into which a tablet of aspirin has just been dropped. Microscopically, molecules are in constant motion in both, the water and the aspirin. The configuration changes from micromoment to micromoment. If we had nothing to work with but the situation at one of these micromoments, i.e., if we had only a single complexion to look at, we could not tell whether the unevenness of distribution—aspirin molecules crowded in one area, water prevailing elsewhere—were highly unusual or typical for the state of affairs under investigation. Only by adding up a sufficient number of momentary complexions over a sufficient length of time can we tell something about the macroscopic state in the glass of water, i.e., establish its entropy.

As an analytical method this approach to thermodynamics represented a revolution. It meant a break with the century-old procedure of accounting for a whole by establishing the relations among its smallest parts. It drew the consequence of the fact that the swirling of molecules constituting a pool of water microscopically shows no kinship with the quiet sight of the pool looked at with the naked eye. Or, to use an example of Lecomte du Nouy: by mixing a white and a black powder one obtains a powder of medium grayness. This homogeneous grayness, however, would not exist for a microscopic insect, which would find itself crawling among black and white boulders (52, p. 10).

Entropy theory is indeed a first attempt to deal with global form; but it has not been dealing with structure. All it says is that a large sum of elements may have properties not found in a smaller sample of them. In arithmetic, the assertion that innumerable sums of plus values and minus values add up to, for instance, plus ten or minus ten or zero is not a statement about structure but about the effect of summation. Similarly, an accumulation of building stones may, at a certain phase of the operation, produce a regular shape of the whole. As I pointed out earlier, the statistical theory of thermodynamics presupposes a condition in which all particles are totally independent of each other, one in which the structure is zero;

21

and it applies its calculations to actual states of affairs in which this condition is met with some approximation. It predicts a steady increase of entropy in closed systems because among the permutations of a given number of elements the irregular ones are much more frequent than the regular ones, and therefore shuffling will increase irregularity until it reaches its maximum.

Under these circumstances it is difficult to agree with the physicist Arthur Eddington, who maintains that entropy, as it is treated today, is "an appreciation of arrangement and organization" and therefore deserves to be placed "alongside beauty and melody." Granted, he says, that entropy admits only the metrical aspects of such things as beauty and melody; but by this limitation it raises "organization" from a vague descriptive epithet to one of the measurable quantities of exact science (23, pp. 73, 95, 105). However, what entropy theory measures is not the nature of organization but only its overall product, namely, the degree of the dissipation of energy it entails, the amount of "tension" available for work in the system. It obtains the measure of this tension level by calculating the probability of its coming about by chance. With such an approach one might indeed be able to estimate the difference in the levels of interrelational tension between a Mozart sonata and the steady sound of an alarm clock, or conceivably even that between a Rubens and a Piero della Francesca, but how much would such an overall score tell about the structure of each of these objects or events?

For the purpose of structural analysis, the state of total independence among elements is not simply zero structure but the limiting case of structure, in which all constraints are absent and in which the action to which the system is subjected —by heat energy or shuffling—has an equal effect on all elements. All elements assume an equal position in the whole and therefore, to repeat what I said earlier about the shuffled deck of cards, they each fulfill the same function. Similarly in the sound of an alarm clock or on a uniformly stained can-

vas all elements do the same work and are therefore indistinguishable.

Needless to say, the entropy theory which has given rise to the notion of disorder I am discussing here is not necessarily the only way of dealing with thermodynamic events; nor does the theory's neglect of structure imply that no such structure actually exists at the molecular level. Köhler has pointed out that the structural aspects (*Verteilungscharakter*) of entropy-increase are most easily overlooked when, for scientific convenience, one concentrates on homogeneous states:

> Any system that attains the maximum of entropy not through a homogeneous state, but by differentiating itself spontaneously into discrete "phases" of very different make-up, demonstrates that aspect of thermodynamic happenings much more impressively (40, p. 53).

Actually, of course, even the molecular particles in a liquid or gas are not truly independent of each other. They hit and attract one another although their relations are loose enough to let the heat energy shuffle them freely. Under these conditions, processes of spatial distribution must take place, roughly comparable perhaps to what can be observed at the human level when a large crowd of people scrambles across an empty auditorium, train, or bathing beach to find suitable locations. Here the struggle for elbow room and breathing space results in an elementary order even under conditions approaching homogeneity of structure. In the arts, the more successful works of Abstract Expressionism, notably Jackson Pollock's paintings of the late 1940s, show a random distribution of sprinkled and splashed pigment controlled by the artist's sense of visual order. He "sees" to it that the overall texture is even and balanced and that the elements of shape and color leave each other sufficient freedom. And when Jean Arp experimented with the "laws of chance," which amounted sometimes to letting shapes fall on a surface and studying the result, he nevertheless worked with much care on the arrangement thus

obtained. In a set of wood reliefs of 1942, *Three Constellations of Same Forms* (Plates 2, 3, 4) he presented a visual interpretation of the chance effect by placing a number of selfcontained forms on an empty ground in such a way that they did not fit any comprehensive compositional scheme but were kept in balance by their mutual weight and distance relations only. Also by showing that the same items could be put together in three different, but equally valid ways he stressed the fortuitous nature of their combination—all this with the delicate control of order he had come to recognize as indispensable. (Cf. Arp's statement on p. 53.)

It may seem that pure, uncontrolled randomness could produce by itself the sort of orderly homogeneity observed in the above examples. However, one must distinguish here between mechanically obtained randomness, such as is based on tables of random numbers or the throwing of dice, and the visual representation of randomness as a type of order. Since mechanically obtained randomness contains all kinds of possible permutations, including the most regular ones, it cannot be relied upon always to exhibit a pervasive irregularity. The skylines of cities, derived so largely from the lawlessness of private enterprise, are products of approximately random behavior but do not all give the visual effect of randomness to the same degree. Some happen to look attractively rhythmical, others have awkward bunches of buildings in some places, empty spots in others. They show neither free variety nor articulate organization but are chaotic. Alfred M. Bork, in an article on "Randomness and the 20th Century," discusses, among other examples of the modern taste, the growing practice in book and magazine design to abolish "justification," i.e., to let the line of type run, without spacing it out in such a way as to obtain a right-hand vertical margin of uniform width (15). Non-justified type creates instead a white strip of randomly varying width, pleasing to the eye by the free rhythm of its irregularity. But even here we find aesthetic freedom attained through control. Unless the printer avoids it by in-

24

tuitive judgment, he is likely to get the same disorderly bunches and hollows that interfere with the effect of randomness in some skylines.

EQUILIBRIUM

The physicist's conception of order, I said earlier, must be considered in relation to his view of (a) the shape situations and (b) the dynamic configurations in physical systems. Having examined the former, I shall now refer to the latter by means of a familiar demonstration. A beaker may contain two different quantities of water, separated by a partition. The water level will be high on the one side, low on the other. The asymmetry of the distribution indicates a store of potential energy, which can be released to do work. If now the partition is pulled out, the water will go through pendulous motions of adjustment resulting in an even, horizontal surface. The system changes from a less probable to a more probable state and its entropy increases.

But something else has also happened. The system, freed from the constraint of the partition, has moved to a state of equilibrium. Naturally, physicists know full well that an increase of entropy often leads to a state of equilibrium. In fact, a leading textbook says of the idea of equilibrium that "in all thermodynamics there is no concept more fundamental than this" (46, p. 16).

Now equilibrium is the very opposite of disorder. A system is in equilibrium when the forces constituting it are arranged in such a way as to compensate each other, like the two weights pulling at the arms of a pair of scales. Equilibrium makes for standstill—no further action can occur, except by outside influence. It also represents the simplest structure the system can assume under the given conditions. This amounts to saying that the maximum of entropy attainable through rearrangement is reached when the system is in the best possible order. Not all states of order can be described by the criterion of equilibrium, but all of them can be said to be at a standstill,

meaning that the present distribution of forces and the shapes resulting from it are the simplest and most fitting embodiment of the system's structure.

When a system changes, especially when it grows, its new size, complexity, function call for a correspondingly modified order. For example, only in fairly simple organisms is the external symmetry of the animal's body reflected in a similar symmetry of the internal organs. In higher animals, internal simplicity of shape may exist at the early embryonic stages. The intestine may be a central, straight tube, only to develop later into a bundle of intricate convolutions. External differentiation of the two sexes is limited to the sex organs in the earliest forms of mammals. Or again, the head detaches itself from the overall shape of the animal body as brain functions become more complex (59). At each ontogenetic or phylogenetic stage a particular balanced order stabilizes itself as the best possible spatial solution for the given organization. There may be transitional stages of disorder, at which changing requirements are in conflict with outdated forms. The incomplete, clashing structures in states of disorder create tensions directed toward the realization of a potential order.

TENSION REDUCTION AND WEAR AND TEAR

Persuaded by the mathematical model of shuffling, where no structural forces other than the shaking-up of independent elements are present, one tends to think of the entropy process as a lawful gradual increase, from minimum to maximum, and indeed as the manifestation of a cosmic force: the force of entropy. But entropy is no such lawful force. It is no force and it does not even describe a process of nature but simply notes its numerical effects. It is a standard of measurement like the gram or the meter, and although the mathematics of probability based on chance can produce a nicely gradual increase of entropy, the world around us and the universe in general do not operate by shuffling, and they lose workable energy by no means smoothly. In fact, the physics of entropy tends to consider only the initial and the final state of a process, not the

dynamic events leading from the one to the other. Lewis and Randall write:

> When a system is considered in two different states, the difference in volume or in any other property, between the two states, depends solely upon those states themselves and not upon the manner in which the system may pass from one state to the other.

And further:

> Thermodynamics exhibits no curiosity; certain things are poured into its hopper, certain others emerge according to the laws of the machine, no cognizance being taken of the mechanism of the process or of the nature and character of the various molecular species concerned (46, pp. 13, 85).

Can we afford to exhibit no curiosity? If we cannot, we may take a chance and speculate that the increase of entropy results from two fundamentally different kinds of processes. One of them is the principle of tension reduction or of decreasing potential energy, often brought about spontaneously by interacting forces under field conditions. This is the favorite of gestalt theory, the tendency toward simplicity, symmetry, regularity. Köhler has called it the Law of Dynamic Direction (41, chap. 8). It is a genuine cosmic principle, directed toward the maximum of orderliness obtainable under the given conditions of a system. However, this tendency of increasing entropy by increasing orderliness depends on the free interaction of forces and is therefore limited by any constraints within the system. Any removal of constraints will broaden the range of its efficiency. If the partition is taken out of the water container, the two unequal bodies of water are set free to attain an equilibrated state of simpler order.

Such constraining partitions can be removed by the hand of man but also by all sorts of natural violence, by crumbling and rusting, erosion or friction. I will call this destruction of shape the catabolic effect. It is the second of the two kinds of fundamental processes mentioned above. Although universally

present, it can hardly be described as a cosmic principle or cosmic law. It is rather a broad, catch-all category, comprising all sorts of agents and events that act in an unpredictable, disorderly fashion and have in common the fact that they all grind things to pieces. This is probably why it can be treated only statistically. Catabolism, one might suggest, is due to the fact that we live in a sufficiently disorderly world, in which innumerable patterns of forces constantly interfere with each other. The catabolic effect, then, increases entropy in two quite different ways: directly by the fortuitous destruction of patterns that are unlikely to be rebuilt by mere chance; indirectly by removing constraints and thus enlarging the range of tension reduction, which increases entropy by simplifying the order of a system.

Order is recognized only when we look at macrostates rather than at the single elements that comprise them. The laws governing the macrostates determine much of what is relevant in human existence and, as Schrödinger and others have pointed out, are unshaken by the fact that wear and tear, such as friction, will modify their practical manifestation in ways that can only be described statistically (61, p. 81; 41, chap. 5; 56, ⁋ 116;33, p. 25). Kepler's laws of planetary motion hold, even though the solar system is slowing down.*

* Some empirically minded thinkers talk about natural laws as though they confused the laws with their actual manifestations. Any law is an If-Then proposition; it indicates what will happen when certain conditions are fulfilled. It refers to these conditions and consequences in their pure shape, which is never met in practice because any physical operation is muffled by the noise due to the interference of other operations. It is this empirical noise that prevents us from predicting any actual occurrence with absolute accuracy. By statistical approximation the underlying lawful mechanism can be made to transpire with more or less clarity, depending on the strength of the noise. Such muffling does not make the law itself statistical but only its practical embodiments; and the insistence on the absolute purity of a law is not a Platonic fantasy but derives from the awareness that to understand is to isolate the relatively simple underlying patterns of forces from their adulterating neighbors.

For anybody engaged in the study of orderly macrostructures, such as those exhibited by works of art, it is interesting to observe with how much anxiety and apology the discovery that causality cannot be determined for the smallest elements of matter has been presented to the Western mind. One is given the impression that macroscopic or molar states are being resorted to only as a way out of this calamity and as the second best available. Correspondingly, it is suggested that macroscopic lawfulness exists only because the disorderly microstates happen to average out to something sensible. Ludwig Boltzmann, who discovered the mathematical relation between entropy and probability, wrote:

> It is solely owing to the fact that we always get the same average values, even when the most irregular occurrences take place under the same circumstances, that we perceive perfectly definite laws even in the behavior of warm bodies (14, p. 316).

Is it foolish to assume that, on the contrary, the microstates average out sensibly because they are controlled by macroscopic laws, such as that of the tendency towards equilibrium; and that we take leave of microevents not only when they elude precise observation but also when we realize that the tracing of elements does not disclose the nature and functioning of the wholes? Even when microevents have a structure and beauty of their own, this structure may bear only indirectly or negligibly on the character of the corresponding global events. Cyril S. Smith, who has long argued for more attention to larger aggregates in physics and chemistry, remarks that "the chemical explanation of matter is analogous to using an identification of individual brick types as an explanation of Hagia Sophia" (62, p. 638).

THE VIRTUE OF CONSTRAINTS

Physicists speak of entropy as a tendency towards disorder when they have their minds set on the catabolic destruction of form. Gestalt theorists, on the other hand, concentrate on

situations in which a disorderly or relatively less orderly constellation of forces is free and indeed compelled to become more orderly. The effect of such processes is best demonstrated when definite constraints arrest them on their way toward final homogeneity. They freeze the constellation and keep it stable. In a system of communicating pipes, water will distribute evenly and stay that way as long as the pipes are watertight. Or, to use an example from visual perception, if a somewhat imperfect line drawing of a square is seen under dim light, it will be perceived as a regular square as long as the stimulus remains active.. A bit of oil dropped on water will please the gestalt theorist by forming a disk, the simplest shape available to the barrier between the two liquids. However, the oil will continue to spread and after a while cover the whole surface—a less satisfactory gestalt.

I have insisted that homogeneous random distribution is a state of order, but at this point we must admit that it is low grade order, a limiting case, nothing to brag about. An essential counteragent is missing. It is this deficiently one-sided sort of orderly composition that physicists have in mind when they describe the thermodynamic end state misleadingly as disorder.

Let us take an example from the arts. An observer with good eyesight looks at a painting by Poussin (Plates 6, 7) and admires its perfect order. The various shapes and colors of the picture, stabilized by the continuous stimulus input, create corresponding units in the nervous system of the observer. These units interact freely in the physiological field within the limits set by the stimulus constraints and thereby create that system of interrelations among segregated elements which the observer experiences as Poussin's composition. Now let the image of the painting become somewhat blurred. If the picture were a less good one, the blurring might improve it. E. H. Gombrich has demonstrated this by placing a painting by Bonnencontre, *The Three Graces*, behind a pane of frosted glass, thus eliminating realistic and erotic irrelevancies and reducing the picture more nearly to its aesthetically active pattern (32, p. 8).

In the case of our Poussin, the blurring might bring out the overall shape of the principal masses more simply, but at the price of a distinct loss. In the blurred image, the compositional order would appear as being obtained more cheaply, that is, without the complexity of formal detail and representational references which make the order of the original so remarkably rich. Possibly the blurred image may be just as orderly as the painting itself, but its order will be at a lower, less valuable level. With increasing catabolic blur, the visual pattern will become simpler, and although we may assume for the argument's sake that it will remain orderly at each level, the value of its order will constantly diminish, leaving us finally with a homogeneously filled and therefore empty rectangular field.*

The demonstration shows, not unexpectedly, that the tendency to tension reduction by simplification describes order incompletely. Tension reduction promotes orderliness; but orderliness is only one aspect of order. The drive to straighten things out, to reduce them economically to their essentials cannot operate in the void. It must have something to work on. Therefore our structural scheme must be broadened to include what I shall call the anabolic tendency. This is the shape-building cosmic principle that accounts for the structure of atoms and molecules, the power to bind and to loose, which makes its symbolic entrance in the Book of Genesis when the creator separates the waters from the dry land. Thermodynamics refers to it as negative entropy, but we cannot here adopt the usage of describing structure as the absence of shapelessness.†

The anabolic tendency contributes what I will call the structural theme of a pattern, and this theme creates orderly form through interaction with the tendency to tension reduction.

* It is technically difficult to demonstrate the reduction of visual complexity resulting from the gradual removal of constraints. In Plates 6, 7 the blurring has been obtained by printing the negative of a reproduction with increasing lack of focus. This introduces additional modifications of shape by diffusion circles, etc.
† Cf. note on p. 15.

Thomson's experiment (cf. p. 5) may aid us here once more. The small floating magnets repel each other and try to withdraw from each other. The large magnet above the bowl attracts them all and thereby makes them approach each other. This antagonistic play of forces is the structural theme; acting upon it is the equilibrating tendency, which leads to the simplest and most stable arrangement the theme can adopt under the circumstances, namely, the regular, circular distribution of the magnets. The constellations of the atomic model or of crystals, flowers or of the unicellular radiolaria are other examples of structural themes subjected to the equilibrating power that gives them their simplest, most regular, most symmetrical shape.

THE STRUCTURAL THEME

The structural theme and accordingly the resulting order are often quite complex. This is so in most works of art. In listening to a piece of music or looking at a sculpture or painting, it is necessary to search for this structural theme of the work, the skeleton, which holds the key to its basic meaning. One example may suffice. What is the structural theme of the Gothic madonna of the early fifteenth century, reproduced in Plate 5? One notices a lateral deviation from the fundamental frontal symmetry of the standing figure. The Virgin is deflected sideways towards the secondary center of the composition, providing a support for the child. This deflection is "measured" visually by the spatial orientation of the scepter, which is tilted away from the vertical like the needle of a compass. Here then is the basic theme: the interaction between the majestic symmetry, verticality, and completeness of a queen and the small but potentially powerful child that has sprung from her and receives its support from her. The relation of mother and child allows, of course, for innumerable interpretations, differing in the distribution of weights, of activity and passivity, dominance and submission, connection and segregation. Each of these many solutions is not only a visual variation but a

different interpretation of the human relation between mother and child in general and the theological relation between Virgin and Christ more in particular. It also conforms to the formal and expressive requirements of a particular style and, indeed, a particular artist.

The structural theme must be conceived dynamically, as a pattern of forces, not an arrangement of static shapes. These forces are made visible, for example, by the confluence of the large folds in the Madonna's garment which lead to the hand supporting the child. The system of folds converging towards the asymmetrically placed secondary center is in contrapuntal tension with the implied symmetry axis of the larger figure, established by the Madonna's head but modulated in her body by the secondary theme. The small child is given visual weight by its compactness and relatively simple shape, but is made subordinate by being turned sideways and placed somewhat lower than his enthroned mother.

This complex theme of forces is readable by virtue of the delicate visual balancing of sizes, distances, directions, curvatures, volumes. Each element has its appropriate form in relation to all the others, thus establishing a definitive order, in which all component forces hold one another in such a way that none of them can press for any change of the interrelation. The play of forces is at a standstill, the maximum of entropy attainable for the given system of constraints has been reached. Although the tension invested in the work is at a high absolute level, it is reduced to the lowest level the constraints will let it assume.

Tension reduction, directed towards a maximum of entropy, is brought about in closed physical systems by the interaction of the forces that constitute the field. This means that the increase in orderliness is due to self-regulation. But such an effect can also be achieved by intervention from the outside. Even within the body of animal or man the processes directed towards equilibrium by mechanical self-distribution differ from the servomechanisms, located in the hypothalamus and else-

33

where, that steer various processes in the body from the outside, as it were, in response to messages received from the critical areas.

Man imposes orderliness on his activities because it is so useful, cognitively and technologically, in a society, a household, a discourse, or a machine. Works of art also are examples of human products created by outside intervention, although here the situation is somewhat complicated by the fact that only in the physical sense is the work of art an object on which a human body operates from the outside. The actual functioning of a painting or piece of music is all mental, and the artist's striving toward orderliness is guided by the perceptual pulls and pushes he observes within the work while shaping it. To this extent, the creative process can be described as self-regulatory. However, here again, as in the physiological mechanisms mentioned above, it is necessary to distinguish between the balancing of forces in the perceptual field itself and the "outside" control exerted by the artist's motives, plans, and preferences. He can be said to impose his structural theme upon the perceptual organization. Only if the shaping of aesthetic objects is viewed as a part of the larger process, namely, the artist's coping with the tasks of life by means of creating his works, can the whole of artistic activity be described as an instance of self-regulation.

At this point I can summarize by returning to the question of L. L. Whyte, who asked about the relation of "the two cosmic tendencies: towards mechanical disorder (entropy principle) and towards geometrical order (in crystals, molecules, organisms, etc.)." Whyte refers to two cosmic tendencies, and so did I; but mine (Figure 3) do not quite fit his. I spoke of the anabolic tendency, which initiates all articulate existence by creating patterns of forces. This tendency, however, does not create "geometrical order" by itself. Organized form requires the interplay of the structural theme, brought about by the anabolic tendency, with a second cosmic tendency, which strives toward tension reduction and thereby attains the simplicity of orderliness. The entropy principle, on the other hand,

cannot be described adequately as a tendency "towards mechanical disorder," because catabolic destruction is only one way of moving from a less probable to a more probable distribution of matter. Nor is destruction by friction, erosion, or cooking the sort of orderly process we tend to have in mind

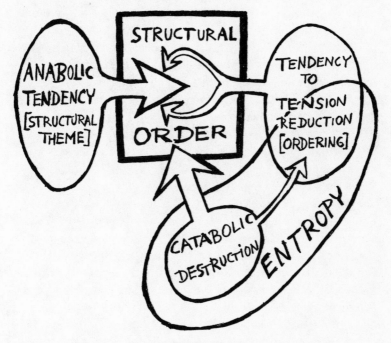

Figure 3.

when we speak of a cosmic tendency. What does supply the entropy principle with an aspect of cosmic order is Köhler's Law of Dynamic Direction, which reduces tension not by dissipating or degrading energy but by organizing it according to the simplest, most balanced structure available to a system.

ii

Here the investigation could stop. The theoretical statements on the principle of entropy sounded as though physical matter moves from order to disorder. This tendency seemed to be in discord with the striving towards order, characteristic of the behavior of human beings and of organisms more in general. I have tried to remind the reader that a tendency to attain order is by no means absent from inorganic systems; it is in fact a characteristic aspect of many processes measured by the increase in entropy. Only in a world based exclusively on the chance combination of independent elements is an orderly pattern a most improbable thing to turn up; in a world replete with systems of structural organization, orderliness is a state universally aspired to and often brought about. To this extent, our findings are reassuring to the friends of order.

At the same time, however, what I have said does not assign to the striving for order or tension reduction the dominant position it has occupied in the thinking of many theorists, especially in the field of aesthetics. A long tradition, going back to Greek philosophy and never quite dislodged by the voices of the occasional dissenters, describes the arts as principally or wholly concerned with the establishment of order, harmony, proportion etcetera. (11, p. 191f). Indeed the contempt of some modern artists for the notion of "beauty" derives precisely from the empty perfection for which beauty has come to stand in much theory and some art; and art critics and theorists would hardly be caught so wholly without defenses by products offering mere orderliness or mere chaos—the two faces of entropy—if they were not paralyzed by their own one-sidedness. Therefore it may be worth referring here to some of the thoughts philosophers and psychologists have devoted to the ideas of order and tension reduction during the last hundred years or so. Their writings suggest prospects as well as pitfalls and are considerably relevant to our present concerns.

The nineteenth century, which produced the principle of entropy, was equally aware of the counterprinciple, the creation of articulate structural "themes," to which I have referred as the anabolic tendency. In particular, the Darwinian theory exhibited the triumphant progress of the animal kingdom from the simplest to the most elaborate organic form. It asserted that the animate world had moved from the simple to the more complex—an evolution that could be interpreted as the very opposite of what the Second Law of Thermodynamics described as the course of the universe. Here was progress or at least increasing articulation rather than degradation of energy. At the same time, Darwinism resembled the statistical version of thermodynamics by relying on chance variation. To be sure, the theory of evolution did not assume that the mere throwing of dice was sufficient to explain the direction in which the arrow of time was moving; nevertheless, the varieties

of specimens from which the fittest were selected for survival were said to have come about by chance mutation.

It seemed most desirable to attribute the progress of the forms of life to a positively directed agent rather than to the blind battering of outside forces. To some extent, at least, this need may have derived from the wish to see nature act in the deliberate and purposeful manner of human creativity and, inversely, to derive man's way of inventing and making things from that of nature. Most characteristic in this respect are the writings of Herbert Spencer in England and Gustav Theodor Fechner in Germany. I am not concerned here with the scant scientific validity of their speculations but with the concepts they contribute to the theory of order.

Spencer in his *First Principles* of 1862, searching for a general law that would account for the "redistribution of matter and motion," came to the conclusion that such a law had to be based on the antagonistic processes of concentration or integration on the one hand and diffusion or dissipation on the other (63). His Law of Evolution, which he believed he could refer back to the Persistence of Force, i.e., the Law of the Conservation of Energy, assumed, first of all, an agglutination of matter, which he called compounding. Drawing on examples from inorganic and organic nature, he observed, for instance, that in the progress of language "the words used for the less familiar things are formed by compounding the words used for the more familiar things" (63, ⁋ 112). In what he thought of as early phases of the visual arts, for example, in Egyptian and Assyrian murals or in medieval tapestries, he failed to see the coordination of parts attained by "paintings since produced." In music, the endless chanting of the savages had evolved into integrated musical forms.

This primary redistribution of matter and motion, however, was said to be accompanied by a secondary and "more remarkable" one, namely, the progressive differentiation from the homogeneous to the heterogeneous. This differentiation came about because the compounding of the whole went with a

39

compounding of each of its parts, thereby separating part from part. To cite again examples taken from the arts, Spencer invented some art history of his own by assuring his readers that the bas-reliefs of the ancients differentiated subsequently into the separate arts of painting and sculpture. In Christian times, secular art split off from religious art; and whereas early art had presented standardized figures, placed in one plane and "exposed to the same degree of light," a later development led to individualized figures of differentiated shape and color, varied in lighting and distance (63, ¶ 124). This latter observation is probably the first instance of the now familiar view that early art develops in lawful stages from simplicity to increasing complexity.

In describing heterogeneity, that is, differentiation, Spencer took pains to distinguish it from what I have called catabolism, namely, decomposition resulting from death, disaster, or social disorder. That would be Dissolution rather than Evolution! Differentiation was an inherent structural unfolding—a notion Spencer took from the German biologist Karl Ernst von Baer's treatise on the evolution of animals, published in 1828.* Heterogeneity was unlike destructive dissolution because it involved a change from the indefinite to the definite:

> Along with an advance from simplicity to complexity, there
> is an advance from confusion to order—from undetermined

* In a footnote to ¶ 119 of his *First Principles*, Spencer reports that in 1852 he learned of von Baer's assertion that every plant and animal, originally homogeneous, becomes gradually heterogeneous. Von Baer's treatise on the history of animal evolution (10) has the motto: *Simplex est sigillum veritatis*! He opposes the biogenetic contention that the embryo of every higher animal passes through the phases of the lower species. Distinguishing between level of development and type of organization (*Ausbildungsgrad* and *Organisationstypus*), von Baer contends that the embryo embodies in the beginning the most general form of its genus ("the embryo of a vertebrate is a vertebrate from the start") and develops towards its particular species from there: "The evolution of the individual is the history of growing individuality in every respect" (vol. I, scholium VI).

40

arrangement to determined arrangement. Development, no matter of what kind, exhibits not only a multiplication of unlike parts, but an increase in the distinctness with which these parts are marked off from one another (63, ¶ 129).

However, Spencer realized that heterogeneity could not increase forever. There is "a degree which the differentiation and integration of Matter and Motion cannot pass." This impassable limit of Evolution is a state of equilibrium, described by Spencer in the terms of the law of entropy, although of course in its nonstatistical formulation and without any indication that he knew of the ideas ripening in the minds of physicists such as Clausius and Lord Kelvin in those same years. By a gradual advance toward harmony, evolution attained a state of cosmic equilibrium, which Spencer saw as "the establishment of the greatest perfection and the most complete happiness" (63, ¶ 176). Neatly distinguished from this ideal state was Dissolution, the complement of Evolution, brought about by an excess of motion through "all actions" operative in the surroundings of the happily balanced state. Spencer's grasp of the relation between equilibration and dissolution may have been vague; but he cannot be said to have confused the two, as later generations did.

THE PLEASURES OF TENSION REDUCTION

Spencer's *First Principles* offered conceptual tools, intended to deal with the interaction between structural theme and ordering tendency. They could have been suggestive to the theory of art; but I have been unable to trace any such application. Another aspect of Spencer's approach, however, was closer to the mainstream of aesthetic speculation. The principle of tension reduction, formulated as a principle of least action, lent itself to a hedonistic interpretation. An early example can be found in Spencer's remarks on "Aesthetic Sentiments," treated with much scorn by Benedetto Croce in his *Aesthetics*. Spencer's chapter comes as a corollary at the very end of his *Principles of Psychology* (64, p. 645). In the traditional manner,

41

art is derived from play, "this useless activity of unused organs." Art specializes in exercizing the least life-serving functions and endeavors to "bring the sensory apparatus into the most effectual unimpeded action." The most perfect form of aesthetic excitement is reached when the "three orders of sensational, perceptional, and emotional gratification are given, by the fullest actions of the respective faculties, with the least deduction caused by painful excess of action."

This approach to psychical economy is worth mentioning because it was influential and because it shows the fatal drop in relevance aesthetic theory suffers when it concentrates on treating art as a source of gratification. Grant Allen's *Physiological Aesthetics* of 1877, dedicated to Spencer, endeavors "to extend in a single direction the general principles which he has laid down" (2). It is a tedious book, based on the assumption that art is concerned with "the emotions." The "intellect" comes in only to the extent to which it produces emotional effects. The attainment of pleasure is the ultimate purpose, which, in the case of art, derives from no "ulterior life-serving" function but is pursued for pleasure's own sake. In consequence, the cognitive input is viewed as nothing better than pleasure-generating stimulation, and the work of art serves to maximize this effect. Order has no other function but that of facilitating stimulation. "The aesthetically beautiful is that which affords the Maximum of Stimulation with the Minimum of Fatigue or Waste, in processes not directly connected with vital functions" (2, p. 39). Economy is pleasurable, and pleasure is the objective of art.

When, later on, this psychophysical economy was recognized as a means of reducing tension, it made contact with the energetic aspect of the entropy principle. Compare here, for example, H. J. Eysenck's "law of aesthetic appreciation," formulated in 1942: "The pleasure derived from a percept as such is directly proportional to the decrease of energy capable of doing work in the total nervous system, as compared with the original state of the whole system" (24, p. 358).

At this point it is well to refer to what I called earlier a

second significant attempt to establish evolution as a cosmic force, namely, Gustav Theodor Fechner's *Some Ideas on the History of the Creation and Evolution of the Organisms* of 1873 (25). Unconvinced and indeed repelled by the Darwinian notion of the survival of the fittest, Fechner conceived of the original state of all being as that of a comprehensive primordial creature, anticipating all existing things in intricate relations and movements, held together only by the force of gravity, and comparable in its chaotic fertility to "a Brazilian forest." Although couched in terms of natural science, Fechner's "cosmorganic" matrix, even more clearly than Spencer's conception, betrays its psychological origin. What he describes is most nearly the initial stage of human creativity, when the mind is a disorderly storehouse of many possibilities—a state of affairs that has its external counterpart in the picturesquely overcrowded studios and studies of many creative persons.

Fechner describes how articulate inorganic and organic structures derive from the primordial matrix through differentiation. This differentiation is distinguished from mere "splitting" by the fact that it produces at each level opposite entities complementing each other, as, for example, male and female (*Prinzip der bezugsweisen Differenzierung*). Through a Lamarckian kind of mutual adaptation, which Fechner considers more effective than the egotistic fight for survival of everybody against everybody, and through the gradual slowing-down of variability (*Prinzip der abnehmenden Veränderlichkeit*) evolution approaches a state of stability:

> For what else do we mean by adaptation (*Zusammenpassen*) but that each part contributes through the effect of its forces to bringing the other parts and thereby the whole into a durable, and this means stable, state and to maintaining them in that state? (25, p. 89)

Fechner's Principle of Stability paraphrases the Second Law of Thermodynamics by postulating that a system must continue to change until full stability is attained, at which point no further alteration can be generated from the inside of the

system. Fechner, like Spencer, gives no indication of knowing about the corresponding theoretical developments in physics, although he does refer to a theory of the Leipzig astronomer and physicist Johann Karl Friedrich Zöllner (73).

Toward the end of his speculations, Fechner added a note in which he related his stability principle to the experiences of pleasure and pain. He stated that any psychophysical excitation, strong enough to pass beyond the threshold of consciousness and to overstep the range of "aesthetic indifference," is invested with pleasure to the extent to which it approaches full stability and with pain through its deviation from it (25, p. 94).* This reference has kept Fechner's otherwise little-known essay in the stream of the modern history of ideas because it was prominently quoted by Freud in his *Beyond the Pleasure Principle* of 1919/20, when he related the pleasure principle to that of tension reduction, i.e., to the increase or decrease of psychical excitation (31). The direct parallel to the Second Law did not escape the attention of Freud's disciples.†
However, no direct reference of Freud himself to the entropy principle is known, so that his one explicit source may indeed be Fechner, the only psychologist, according to Ernest Jones, from whom Freud ever borrowed any ideas (35, vol. 3, p. 268).

The state of stability was for Fechner one of supreme cosmic

* It is this psychological version of the principle which Fechner seems to have taken from Zöllner. Zöllner's treatise on the nature of the comets contains a chapter "on the general properties of matter," in which he equates physical tension reduction with the striving toward pleasure and arrives at the following formulation: "All work done by organic or inorganic natural entities is determined by the sensations of pleasure and displeasure in such a way that the movements within a closed realm of phenomena behave as though they pursued the unconscious purpose of reducing the sum of unpleasant sensations to a minimum" (73, p. 326).
† Thus Siegfried Bernfeld: "Physical systems for which the entropy principle holds behave as though they possessed a drive to reduce their internal quantities of tension within the system as a whole." (12, p. 53).

order. No such conception exists for Freud, except when he mentions the "constancy principle," a tendency to keep excitatory tension at an even keel. These references, however, are perfunctory and do not fit the trend of his thought. What he wishes to prove is that the striving to keep tension at a minimum or to eliminate it entirely is the dominant tendency of psychophysical existence (Nirvana principle). Such tension reduction is conceived by Freud as catabolic dissolution. Instincts are drives of the live organism to return to the inorganic state. The goal of life is death (27, chap. 4).

The striving toward tension reduction is, according to Freud, not only dominant but indeed the only genuinely primary tendency of the organism. The life-sustaining instincts are mere detours, hesitations, imposed reactions to disturbances. There is no inherent drive towards higher development, perfection, novelty.* Hence the essentially negative and static character of Freud's "dynamic" philosophy, whose affinity to that of Schopenhauer he explicitly acknowledges. Stimulation from the outside and impulses from the inside are viewed as producing disturbing tension, and the strategy of the Ego endeavors to steer the mind toward desirable quiescence. David Riesman has observed: "It seems clear that Freud, when he looked at love or work, understood man's physical and psychic behavior in the light of the physics of entropy and the economics of scarcity" (60, p. 325).

The notion of "psychic economy" is a reinterpretation of the Principle of Least Action. In its early formulations, this principle, variously formulated by Leibniz, Maupertuis, Lagrange, and others, dealt with mechanics and was meant to describe the behavior characteristic of inorganic nature, which

* Even in his later writings, in which he based his conception of the human drives on the antagonistic pair of Eros and Destructiveness, corresponding to inorganic attraction and repulsion, Freud insisted that the drives, although causes of all action, are conservative in nature: they strive to reestablish the original inorganic state. (Cf. 29, chap. 2, and 30, chap. 32).

45

tends to accomplish changes by a minimum of action.* This economy of effort was related to the notion that "nature is pleased with simplicity," as Newton put it in his *Mathematical Principles* (book III, rule I). The rule of parsimony in science, according to which a theory is to be preferred when it is simpler and when it employs a minimum of components, was justified by this property of nature: the simpler theory was more likely to be correct. The very different notion that the simpler procedure is preferable because a man would be foolish if he did more work than he had to is probably a pathological outgrowth of the industrial revolution. One must carefully distinguish the assertion that tension reduction in an organized system will increase orderliness and that the economy of means will enhance the efficiency of action and product, from the belief that man is lazy and therefore pleased to get the most through the smallest effort. Obviously, the work of art, like an organism or a machine or a society, profits from the economy of orderly structure, but this benefit is not obtained by a lessening of effort. On the contrary, parsimonious structure is the fruit of laborious struggle. Even the simplest shapes, such as the straight line in drawing or the geometrically shaped limbs of African wood figures are by no means the simplest to make. Furthermore, most works of art are very complex. Scientists also are not known to shy away from exacting tasks.†

* On Maupertuis see Jerome Fee (26). Also Planck: "Das Prinzip der kleinsten Wirkung" (1915) in Planck (58) and the literature cited in Zipf (72, p. 545). Here again I am not concerned with the validity of the principle in the light of modern physics but with its nature as a philosophical postulate.

† A personal recollection may find its place here. Max Planck, the great pioneer of quantum theory, who wrote in the aforementioned paper that the Principle of Least Action "is suited to occupy the highest position among all physical laws," was a devoted mountain climber. I remember sitting at a table next to his in the breakfast room of a small pension in the Dolomites. He was then in his middle seventies. That morning, Mrs. Planck had come downstairs first and while waiting for her husband was studying a map. When Planck joined her, she told him that she had just figured out a way

Unimpaired minds and bodies are not inclined to exert themselves as little as possible or to reduce the complexity of their actions and products for that reason.

HOMEOSTASIS IS NOT ENOUGH

The references to Freud's basic attitude may have helped to show that the principle of tension reduction leads to a lopsided view if one fails to acknowledge that one of its essential aspects is the creation of order and further that by limiting attention to this one principle a static and negative conception results. One more notable example from biology and psychology may complete this sketchy survey.

Around 1930, the physiologist Walter B. Cannon showed that the steering mechanisms of the autonomic nervous system sustain an orderly state in the organism through the balancing of opposite forces (20). Homeostasis, as he called it, is the maintenance of temperature and the supply of oxygen, water, sugar, and salt, fat, calcium at suitable levels. Cannon was careful to distinguish homeostasis, which provides an optimal relation between output and input, from the unopposed tendency to tension reduction. Far from representing a striving toward deadly dissolution, the tendency to homeostasis had come about in biological evolution as a means of preserving life. Instead of the stagnation created by a state of maximum entropy, the open system of the organism constituted a steady stream of absorbed and expended energy.

Cannon's thesis not only illustrates the difference between minimal functioning and maximal vigor but also the incompleteness of any conception of order based on equilibrium alone. There was great temptation to apply Cannon's physiological model to psychology and to describe human motivation as a striving for the maintenance of stability. The backing of a respectable natural science seemed to be available for an

of approaching the peak they were to climb that day. Planck was not pleased. "You have cheated me out of my morning problem." I heard him say—surely a most uneconomical reaction.

approach close enough to the theory of the conservative nature of human drives, as Freud had first introduced it. However, soon there was trouble. It became evident that such a static conception of psychophysical functioning was neither in keeping with Cannon's view nor did it do justice to the motivational aspects of the mind. As Cannon had seen it, the homeostatic devices were limited to taking care of the routine necessities of life through automatic regulation in order to free body and mind for "the activity of the higher levels of the nervous system;" and some psychologists began to realize that, in the words of Christian O. Weber, "homeostatic balance makes it possible to live at all but contributes little to living well" (67). It establishes order but does not indicate what this order is to be about. For a more adequate view of human nature it is necessary to take into account the goals of life, the striving toward growth and stimulation, the lures of curiosity and adventure, the joy of exercising body and mind, and the desire for accomplishment and knowledge.

A NEED FOR COMPLEXITY

What does our look at the thinking of physicists, philosophers, psychologists, and physiologists suggest for the understanding and evaluation of art? I have tried to show that the activities of nature and of man cannot be said to be basically at odds with each other. Man's striving for order, of which art is but one manifestation, derives from a similar universal tendency throughout the organic world; it is also paralleled by, and perhaps derived from, the striving towards the state of simplest structure in physical systems. This cosmic tendency towards order, I maintained, must be carefully distinguished from catabolic erosion, which afflicts all material things and leads to disorder or more generally to the eventual destruction of all organized shape.

The rehabilitation of order as a universal principle, however, suggested at the same time that orderliness by itself is not sufficient to account for the nature of organized systems in general or for those created by man in particular. Mere orderliness

48

leads to increasing impoverishment and finally to the lowest possible level of structure, no longer clearly distinguishable from chaos, which is the absence of order. A counterprinciple is needed, to which orderliness is secondary. It must supply what is to be ordered. I described this counterprinciple as the anabolic creation of a structural theme, which establishes "what the thing is about," be it a crystal or a solar system, a society or a machine, a statement of thoughts or a work of art. Subjected to the tendency toward simplest structure, the object or event or institution assumes orderly, functioning shape.

In practical matters, there are good reasons for keeping a structural theme as simple as possible and the expense of energy at a minimum. However, when it comes to the whole of human existence, whose only goal is its own fullness, the structural theme must not only be present but also as rich as possible. This demand upon all knowledge, invention, and creation is foreshadowed in the traditional view of the world as a creation of God. Arthur O. Lovejoy, in his classic monograph on the principle of plenitude, has traced through the history of Western thought the idea that the universe, in order to be worthy of the conception of God, had to contain the complete set of all possible forms of existence. And it is precisely because "God makes the greatest number of things that he can," that the laws of nature have to be as simple as possible (47, p. 179). A bewildering complexity is certainly characteristic of organic shape.

The arts, as a reflection of human existence at its highest, have always and spontaneously lived up to this demand of plenitude. No mature style of art in any culture has ever been simple. In certain cultures, an overall symmetry may conceal the complexity of the work at first glance. More careful examination reveals in Egyptian sculpture a subtlety of curves which only the sense of touch can verify with certainty, but which is indispensable nevertheless in animating visually the simple architecture of the whole. Similarly, in African carvings an inexhaustible formal invention presents ever new variations of the basic human form. The Parthenon is not simple, nor are

49

the buildings of Le Corbusier. "The human brain, the most complex object in the world, cannot be represented by an easily exhausted shape or gesture" (6, p. 63).

There is no need to rediscover here the ancient formula of "unity in variety." It will have been noticed that even in the hedonistic formulations of a Spencer, Allen, Eysenck, the pleasures of the least effort are to be derived not from the simplest available patterns but presuppose the "fullest actions" of the pertinent mental faculties, the "maximum of stimulation," drawing from the nervous system "the maximum amount of energy" (24, p. 359). Recent experimental studies have led to the conclusion that a distinguishing feature of creative persons is "a cognitive preference for complexity—the rich, dynamic, and asymmetrical—as opposed to simplicity" (22, p. 59).

Even the most traditional aesthetic taste does not limit itself, in the more sensitive observers, to considering beauty exclusively as the absence of distorting stresses, although Classicist theory concentrates on this aspect. Johann Joachim Winckelmann, famous for his advocacy of "edle Einfalt und stille Grösse" (noble simplicity and quiet grandeur) observed nevertheless:

The line that describes the beautiful is elliptical. It has simplicity and constant change. It cannot be described by a compass, and it changes direction at every one of its points. This is easily said but hard to learn: no algebra can determine which line, more or less elliptical, will mold the various parts into beauty. But the ancients knew it, and we find it in their human figures and even their vessels. Just as there is nothing circular in the human body, so no profile of an ancient vessel describes a half circle.*

* See Winckelmann's "Erinnerung über die Betrachtung der alten Kunst," "Gedanken über die Nachahmung der griechischen Werke in der Malerei und Bildhauerkunst," published in 1755, and "Beschreibung des Torso im Belvedere zu Rom." William Hogarth's "line of beauty," referring to a similar observation, appears first as a "serpentine-line lying on a painter's pallet" in a self-portrait published in 1745 as a frontispiece to his engraved works and is

Winckelmann's infatuated observations on Hellenistic statues, such as the torso of the Belvedere, show clearly that in practice the visual tension animating the human form was to him as indispensable for beauty as were simplicity and quietness. Structural analysis can live up to these requirements only by distinguishing between orderliness and order. Mere orderliness is promoted when the striving toward tension reduction balances all components of a field against each other. Tension reduction is achieved also when, in the interest of orderliness, superfluous components are eliminated from a system and needed ones are supplied; for any gap within an order or any surplus element produces a tension toward completion or removal, which is eased by ordering. All such ordering increases entropy; although, as I pointed out earlier, the opposite is not true. Not every increase of entropy comes about by ordering: an explosion, blowing a structure to bits, rarely increases orderliness.

Orderliness comes from the maximum of tension reduction obtainable for a given pattern of constraints. When more constraints are removed, tension reduction can proceed further until it reaches homogeneity.

Homogeneity is the simplest possible level of order because it is the most elementary structural scheme that can be subjected to ordering. Orderliness comes in degrees; order comes in levels. A structure can be more or less orderly at any level of complexity. The level of ordered complexity is the level of order. The "aesthetic measure" at which George Birkhoff aimed was merely a measure of order, derived from the relation between orderliness and complexity (13). Order, I shall suggest, is a necessary although not a sufficient condition of aesthetic excellence.*

amply discussed, of course, in his *Analysis of Beauty*. On the dynamic expression of circle and parabola see also Chapter 10 of my *Art and Visual Perception*. The preference of the Renaissance for circular shape and of Mannerism for the ellipse is described by Panofsky (53, p. 25).
* Order can be analyzed with the tools of gestalt psychology, which,

Let me return once more to the fact that the increase of entropy is due to two quite different kinds of effect; on the one hand, a striving toward simplicity, which will promote orderliness and the lowering of the level of order, and, on the other hand, disorderly destruction. Both lead to tension reduction. The two phenomena manifest themselves more clearly the less they are modified by the countertendency, namely, the anabolic establishment of a structural theme, which introduces and maintains tension. In the arts the theme represents what the work "is about." When its influence is weakened, one of two things will happen. Either the need for simplicity will no longer be counterbalanced by complex experience and invention. Released from these constraints, it will yield all the more strongly to the pleasure of tension reduction and content itself with a minimal structure at a low level of order. In the extreme, it will reach the emptiness of homogeneity.*

Or, in the other case, organized structure will simply suc-

in principle, has ways of determining levels of complexity as well as degrees of orderliness. This does not mean that a high level of order is the same as a "good gestalt"—an unfortunate term, which, in some of the early gestalt writings, burdened a purely descriptive concept with a value judgment and made a definite structural condition look subjective and vague. The term was used to describe the tendency toward regularity, symmetry, simplicity, best named "the law of simplicity" or perhaps "the law of dynamic direction," as Köhler called it in 1938 (41). Because of the vagueness of the term, "good gestalt," the law of simplicity was readily confused with "praegnanz", meaning clear-cut structure, or with whatever else may be perceptually and aesthetically enjoyable, interesting, appropriate, or useful. The result can be studied, e.g., in Eysenck's attempt to identify the "good gestalt" with the "beautiful" (24). His paper, just as the book by Birkhoff, presents a theory of aesthetic order; the law of simplicity refers only to orderliness attained by tension reduction.
* Some of the same people who profess to be repelled by the monotonous rows of identical human dwellings in so-called subdivisions, seem to admire rows of identical boxes in art galleries.

cumb to disintegration, either by corrosion and friction or by the mere incapacity to hold together. Collapse by exhaustion has been powerfully demonstrated, although not necessarily expressed and interpreted artistically, by an American sculptor, who recently showed deflated giant models of orderly functional instruments, such as typewriters or electric fans. A wreck, unless it assumes a shape of its own, will be disorderly and therefore more or less unreadable to the eye, but it can be ominous and foreboding as subject matter.

A mind released from the demands of organized experience may content itself with the shapelessness of accidental materials, happenings, or sounds. Mere noise involves a minimum of structural tension and therefore calls for a minimum of energy expended by producer and recipient, in spite of creating the illusion that much is going on. In the extreme case, again, it will reach the emptiness of homogeneity.

The writings of the sculptor and painter Jean Arp contain a telling example (9, p. 77). In a crucial period of his life Arp found himself moving from the extreme of "impersonal, severe structures," intended to eliminate the burden of personal experience, to the forsaking of defined form and the acceptance of dissolution.

About 1930 the pictures torn by hand from paper came into being. Human work now seemed to me even less than piece-work. It seemed to me removed from life. Everything is approximate, less than approximate, for when more closely and sharply examined, the most perfect picture is a warty, threadbare approximation, a dry porridge, a dismal mooncrater landscape. What arrogance is concealed in perfection. Why struggle for precision, purity, when they can never be attained. The decay that begins immediately on completion of the work was now welcome to me. Dirty man with his dirty fingers points and daubs at a nuance in the picture. This spot is henceforth marked by sweat and grease. He breaks into wild enthusiasm and sprays the picture with spittle. A delicate paper collage of watercolor is lost. Dust

and insects are also efficient in destruction. The light fades the colors. Sun and heat make blisters, disintegrate the paper, crack the paint, disintegrate the paint. The dampness creates mould. The work falls apart, dies. The dying of a picture no longer brought me to despair. I had made my pact with its passing, with its death, and now it was part of the picture for me. But death grew and ate up the picture and life. This dissolution must have been followed by the negation of all action. Form had become unform, the Finite the Infinite, the Individual the Whole.

Clearly, the earlier insistence on minimal shapes of the utmost precision and the subsequent display of corrosion, seemingly at extreme opposites, were in fact symptoms of the same abandonment. It was the work of a fellow-artist, his wife Sophie Taeuber, that showed him "the fine balance between Above and Below, light and darkness, eternity and transitoriness." And he concluded: "Today even more than in my youth I believe that a return to an essential order, to a harmony, is necessary to save the world from boundless confusion."

To be sure, what looks like disorder today may turn out to be the order of tomorrow. This has happened before and is likely to repeat itself in the future. But it does not release us from the responsibility of diagnosing disorder where, to the best of our judgment, it prevails. Nor does it give us license to accept disorder in the work of an artist as an interpretation of disorder when we recognize it as a mere addition to it. Then again, it is quite true that a very simple display may release a strong and highly articulate experience in the recipient. Religious and political symbols do so commonly. An evenly stained canvas, a nest of squares, a shiny egg, a set of stripes, or an assortment of refuse may stir up powerful feelings here and there. Anything in the world can do that. In such cases, the tension of high anabolic order may be called forth by, but will not be a property of, the object or event acting as catalyst. If a drug could stimulate in somebody's mind the invention of a

great work of art, would we credit it to the drug or to its user? A work of art does not ask for meaning; it contains it.

Disintegration and excessive tension reduction must be attributed to the absence or impotence of articulate structure. It is a pathological condition, on whose causes I can hardly speculate here. Are we dealing with the sort of exhaustion of vital energy that prophets and poets proclaimed and decried in the last century? Is the modern world socially, cognitively, perceptually devoid of the kind of high order needed to generate similarly organized form in the minds of artists? Or is the order of our world so pernicious as to prevent the artist from responding to it? Whatever the cause, these products, although often substandard artistically, reveal strongly positive objectives: an almost desperate need to wrest order from a chaotic environment, even at the most elementary level; and the frank exhibition of bankruptcy and sterility wrought by that same environment.

CALL FOR STRUCTURE

The call for articulate structure is not merely a matter of form. Variety is more than a means of avoiding boredom, since art is more than an entertainment of the senses. I mentioned in the beginning that perceptual order rarely, if ever, exists for its own sake but is the external manifestation of an internal order (as in a crystal) or of a functional order (as in a building or machine), or is intended as a portrayal of a significant type of order existing elsewhere. In this latter case, the case of the work of art, the structural theme derives its value—even much of its value as a stimulant—from the human condition whose particular form of order it makes visible or audible. A structural theme deserves to be ordered, to become a message, because of what it says about man and world. Thus we cannot content ourselves with the demand that the performance of the artist be sufficiently rich to fit the level of complexity at which our brains function. A high level of structural order is a necessary but not sufficient prerequisite of art. What is ultimately

required is that this order reflect a genuine, true, profound view of life. Here, however, we overstep the limits of the present investigation.

One more point. It was noted that freely interacting natural forces strive towards a state of equilibrium, which represents the final order of the constellation. Such a final state, at which all is well, is also foreseen by philosophers, social reformers, therapists. But perfection, being a standstill, has often been viewed with justified discomfort, and the definitive order of utopias and heavens smacks inevitably of boredom. Kant, speaking of The End of All Things, has said of the Day of Judgment that it will still belong to time because something will still be happening, as distinguished from eternity, when, in the words of the angel of *Revelation*, there shall be time no longer. Now the work of art also represents a state of final equilibrium, of accomplished order and maximum relative entropy, and there are those who resent it. But art is not meant to stop the stream of life. Within a narrow span of duration and space the work of art concentrates a view of the human condition; and sometimes it marks the steps of progression, just as a man climbing the dark stairs of a medieval tower assures himself by the changing sights glimpsed through its narrow windows that he is getting somewhere after all.

PLATES

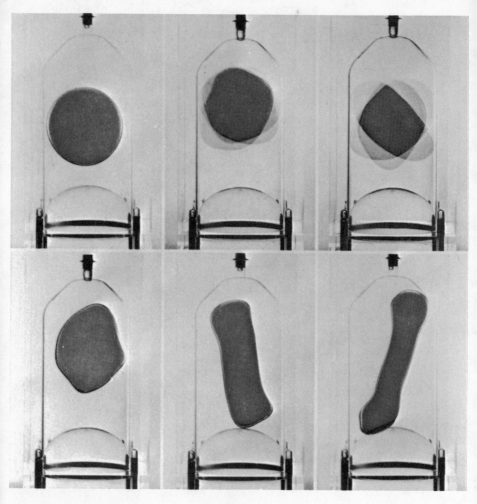

Plate 1.

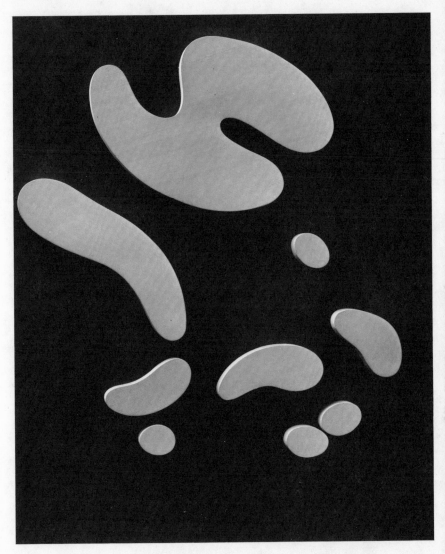

Plates 2–4. Jean Arp. *Three Constellations of Same Forms.*
Triptych. Here reproduced by courtesy of the owner,
Mrs. Aja Petzold, Basle, Switzerland.

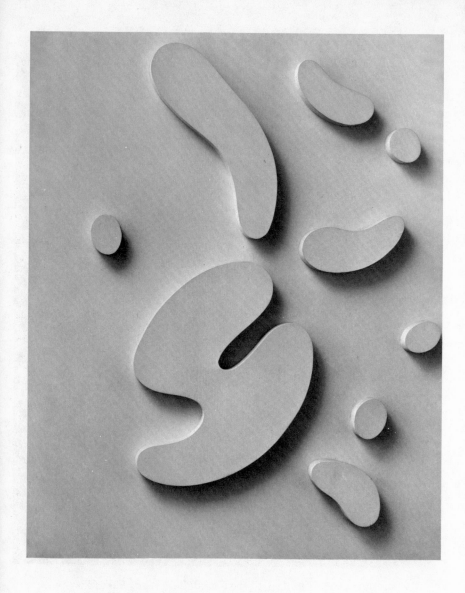

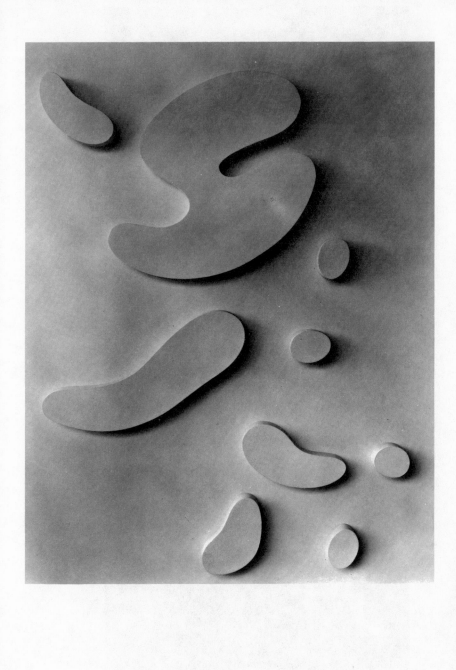

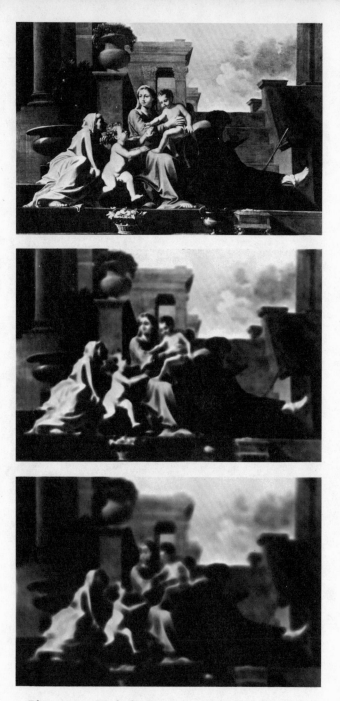

Plates 6, 7. Nicholas Poussin. *Holy Family on the
Steps.* National Gallery of Art. Washington, D. C.
Samuel H. Kress Collection.

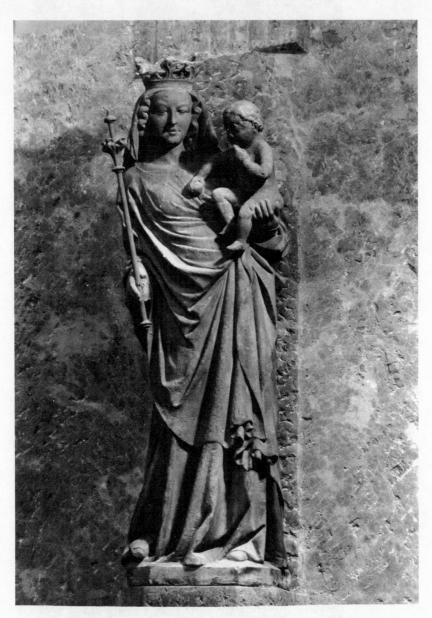

Plate 5. The Madonna of Würzburg. Photo Zwicker, Würzburg.

BIBLIOGRAPHY

1 Adams, Henry. The degradation of the democratic dogma. New York: Peter Smith, 1949.
2 Allen, Grant. Physiological aesthetics. New York: Appleton, 1877.
3 Angrist, Stanley W. and Loren G. Hepler. Order and chaos: Laws of energy and entropy. New York: Basic Books, 1967.
4 Arnheim, Rudolf. Accident and the necessity of art. In Arnheim (8) pp. 162–180.
5 Arnheim, Rudolf. Art and visual perception. Berkeley and Los Angeles: Univ. of California Press, 1969.
6 Arnheim, Rudolf. The critic and the visual arts. Fifty-second Biennial Convention of the American Federation of Arts in Boston. New York: AFA, 1965.
7 Arnheim, Rudolf. Order and complexity in landscape design. In Arnheim (8) pp. 123–135.
8 Arnheim, Rudolf. Toward a psychology of art. Berkeley and Los Angeles: Univ. of California Press, 1966.
9 Arp, Jean. On my way. Poetry and essays 1912–1947. New York: Wittenborn, Schultz, 1948.
10 Baer, Karl Ernst von. Ueber Entwicklungsgeschichte der Tiere: Betrachtung und Reflexion. Königsberg: Bornträger, 1828.
11 Beardsley, Monroe C. Order and disorder in art. In Kuntz (43) pp. 191–218.
12 Bernfeld, Siegfried. Die Gestalttheorie. Imago 1934, vol. 20, pp. 32–77.
13 Birkhoff, George D. Aesthetic measure. Cambridge, Mass.: Harvard Univ. Press, 1933.
14 Boltzmann, Ludwig. Weitere Studien über das Wärmegleichgewicht unter Gasmolekülen. Sitzungsber. d. kö-

nigl. Akad. d. Wiss., Vienna: 1872. *Reprinted in* Boltz-mann: Wissenschaftliche Abhandlungen. Leipzig: Barth, 1909, vol. 1.

15 Bork, Alfred M. Randomness and the 20th century. Antioch Review, 1967, vol. 27, pp. 40–61.

16 Bragg, Sir William. Concerning the nature of things. New York: Dover, 1948.

17 Brush, Stephen G. Thermodynamics and history. Graduate Journal 1967, vol. 7, pp. 477–565.

18 Butor, Michel. Répertoire III. Paris: Editions de Minuit, 1968.

19 Cage, John. A year from Monday. Middletown: Wesleyan Univ. Press, 1969.

20 Cannon, Walter B. The wisdom of the body. New York: Norton, 1963.

21 Chipp, Herschel B. (ed.). Theories of modern art. Berkeley and Los Angeles: Univ. of California Press, 1968.

22 Dellas, Marie and Eugene L. Gaier. Identification of creativity. Psychol. Bull. 1970, vol. 73, pp. 55–73.

23 Eddington, Sir Arthur. The nature of the physical world. Ann Arbor: Univ. of Michigan Press, 1963.

24 Eysenck, H. J. The experimental study of the "good gestalt" —a new approach. Psychol. Review 1942, vol. 49, pp. 344–364.

25 Fechner, Gustav Theodor. Einige Ideen zur Schöpfungs– und Entwicklungsgeschichte der Organismen. Leipzig: Breitkopf & Härtel, 1873.

26 Fee, Jerome. Maupertuis and the principle of least action. Scient. Monthly, June 1941, vol. 52, pp. 496–503.

27 Flugel, J. C. Studies in feeling and desire. London: Duckworth, 1955.

28 Frank, Helmar. Zur Mathematisierbarkeit des Ordnungsbegriffs. Grundlagenstudien aus Kybernetik und Geisteswissenschaft, vol. 2, 1961.

29 Freud, Sigmund. Abriss der Psychoanalyse. *In* Schriften aus dem Nachlass, 1892–1938. London: Imago, 1941. (Outline of psychoanalysis. New York: Norton, 1945.)

30 Freud, Sigmund. Neue Folge der Vorlesungen zur Einführung in die Psychoanalyse. Vienna: Intern. Psychoanal.

Verlag, 1933. (New introductory lectures on psycho-analysis. New York: Norton, 1965.)

31 Freud, Sigmund. Jenseits des Lustprinzips. Leipzig: Intern. Psychoanal. Verlag, 1923. (Beyond the pleasure principle. New York: Liveright, 1961.)

32 Gombrich, E. H. Psychoanalysis and the history of art. Intern. Journal of Psycho-analysis, 1954, vol. 35, pp. 1–11.

33 Heisenberg, Werner. Das Naturbild der heutigen Physik. Hamburg: Rowohlt, 1955.

34 Hiebert, Erwin N. The uses and abuses of thermodynamics in religion. Daedalus, Fall 1966, pp. 1046–1080.

35 Jones, Ernest. The life and work of Sigmund Freud. New York: Basic Books, 1957.

36 Kepes, Gyorgy (ed.). Structure in art and science. New York: Braziller, 1965.

37 Kiemle, Manfred. Aesthetische Probleme der Architektur unter dem Aspekt der Informationsästhetik. Quickborn: Schnelle, 1967.

38 Köhler, Wolfgang. Zur Boltzmannschen Theorie des zweiten Hauptsatzes. Erkenntnis 1932, vol. 2, pp. 336–353.

39 Köhler, Wolfgang. On the nature of associations. Proc. Amer. Philos. Soc., June 1941, vol. 84, pp. 489–502.

40 Köhler, Wolfgang. Die physischen Gestalten in Ruhe und im stationären Zustand. Braunschweig: Vieweg, 1920.

41 Köhler, Wolfgang. The place of value in a world of facts. New York and Toronto: New Amer. Library, 1966.

42 Kostelanetz, Richard. Inferential art. Columbia Forum, Summer 1969, vol. 12, pp. 19–26.

43 Kuntz, Paul G. (ed.). The concept of order. Seattle and London: Univ. of Washington Press, 1968.

44 Laing, R. D. The divided self. Baltimore: Penguin, 1965.

45 Landsberg, P. T. Entropy and the unity of knowledge. Cardiff: Univ. of Wales Press, 1961.

46 Lewis, Gilbert Newton and Merle Randall. Thermodynamics and the free energy of chemical substances. New York: McGraw-Hill, 1923.

47 Lovejoy, Arthur O. The great chain of being. New York: Harper and Row, 1960.

48 Meyer, Leonard B. Music, the arts, and ideas. Chicago and London: Univ. of Chicago Press, 1967.

49 Moles, Abraham. Information theory and esthetic perception. Urbana and London: Univ. of Illinois Press, 1966.

50 Morel, Bénédict Auguste. Traité des dégénérescences physiques, intellectuelles et morales de l'espèce humaine, etc. Paris and New York: Baillière, 1857.

51 Nordau, Max. Entartung. Berlin: Duncker, 1893. (Degeneration. New York: Appleton, 1895.)

52 Nouy, Pierre Lecomte du. L'homme et sa destinée. Paris: Colombe, 1948. (Human destiny. New York: Longmans, Green, 1947.)

53 Panofsky, Erwin. Galileo as a critic of the arts. The Hague: Nijhoff, 1954.

54 Pascal, Blaise. Pensées. Montréal: Editions Variétés, 1944.

55 Planck, Max. Eight lectures on theoretical physics. New York: Columbia, 1915.

56 Planck, Max. Einführung in die Theorie der Wärme. Leipzig: Hirzel, 1930.

57 Planck, Max. Die Einheit des physikalischen Weltbildes. *In* Planck (58) pp. 28–51.

58 Planck, Max. Vorträge und Erinnerungen. Darmstadt: Wissensch. Buchgemeinschaft, 1969.

59 Portmann, Adolf. Die Tiergestalt. Freiburg: Herder, 1965.

60 Riesman, David. The themes of work and play in the structure of Freud's thought. *In* Riesman: Individualism reconsidered. Glencoe: Free Press, 1954.

61 Schrödinger, Erwin. What is life? Cambridge and New York: Cambridge Univ. Press, 1945.

62 Smith, Cyril Stanley. Matter versus materials: a historical view. Science, Nov. 8, 1968, vol. 162, pp. 637–644.

63 Spencer, Herbert. First principles. New York: Crowell, n.d.

64 Spencer, Herbert. Principles of psychology. New York: Appleton, 1878.

65 Thomson, Joseph John. The corpuscular theory of matter. New York: Scribner, 1907.

66 Tyndall, John. Heat—a mode of motion. New York: Appleton, 1883.

67 Weber, Christian O. Homeostasis and servo-mechanisms for what? Psychol. Review 1949, vol. 56, pp. 234–239.

68 Weisstein, Naomi. What the frog's eye tells the human brain: single cell analyzers in the human visual system. Psychol. Review 1969, vol. 72, pp. 157–176.

69 Whyte, Lancelot Law (ed.). Aspects of form. London: Lund Humphries, 1968.

70 Whyte, Lancelot Law. Atomism, structure, and form. *In* Kepes (36) pp. 20–28.

71 Wiener, Norbert. The human use of human beings. Boston: Houghton Mifflin, 1950.

72 Zipf, George Kingsley. Human behavior and the principle of least effort. Cambridge, Mass.: Addison-Wesley, 1949.

73 Zöllner, Johann Karl Friedrich. Ueber die Natur der Cometen: Beiträge zur Geschichte und Theorie der Erkenntnis. Leipzig: Engelmann, 1872.

INDEX

Adams, Henry, 9
Allen, Grant, 42, 50
Angrist, Stanley W., 8
Arnheim, Rudolf, 3, 51
Arp, Jean (Hans), 23, 24, 53

Baer, Karl Ernst von, 40
Baudelaire, Charles, II, 9
Beardsley, Monroe C., 12
Bernfeld, Siegfried, 44
Birkhoff, George, 51, 52
Boltzmann, Ludwig, 9, 29
Bonnencontre, Ernest, 30
Bork, Alfred M., 24
Bragg, William, 6
Brush, Stephen G., 9
Butor, Michel, 2

Cage, John, 11, 17
Cannon, Walter B., 47, 48
Clausius, Rudolf, 9, 41
Croce, Benedetto, 41
Curie, Pierre, 5

Darwin, Charles, 38, 43

Eddington, Arthur, 22
Eysenck, H. J., 42, 50, 52

Fechner, Gustav Theodor, 39, 43, 44
Fee, Jerome, 46
Feibleman, James K., 13
Foerster, Thomas von, 6
Frank, Helmar, 20
Freud, Sigmund, 44, 45, 47, 48

Gombrich, E. H., 30

Hepler, Loren G., 8
Hogarth, William, 11, 50
Holton, Gerald, 6

Jones, Ernest, 44

Kant, Immanuel, 56
Kelvin, Lord, 9, 41
Kepler, Johann, 28
Kiemle, Manfred, 20
Köhler, Wolfgang, 5, 13, 23, 27, 35, 52
Kostelanetz, Richard, 11

Lagrange, Joseph-Louis, 45
Laing, R. D., 13
Lamarck, Jean-Baptiste, 43
Landsberg, P. T., 12
Le Corbusier, 50
Leibniz, Gottfried Wilhelm, 45
Lewis, Gilbert N., 27
Lombroso, Cesare, 10
Lovejoy, Arthur O., 49

Mach, Ernst, 5
Malevich, Kasimir, 10
Maupertuis, Pierre-Louis M. de, 45, 46
Morel, Bénédict Auguste, 9, 10
Mozart, Wolfgang Amadeus, 19, 22

Newton, Isaac, 46
Nordau, Max, 9
Nouy, Pierre Lecomte du, 21

Panofsky, Erwin, 51
Pascal, Blaise, 2, 14
Piero della Francesca, 22
Planck, Max, 7, 14, 46, 47
Pollock, Jackson, 23
Poussin, Nicolas, 30, 31

Randall, Merle, 27
Riesman, David, 45
Rubens, Peter Paul, 22